The Art of Holy Week and Easter

Meditations on the Passion and Resurrection of Jesus

Sister Wendy Beckett

InterVarsity Press, USA
P.O. Box 1400
Downers Grove, IL 60515-1426, USA
ivpress.com
email@ivpress.com

Society for Promoting Christian Knowledge
36 Causton Street
London SW1P 4ST, England
www.spck.org.uk

InterVarsity Press® is the book-publishing division of InterVarsity Christian Fellowship/USA®, a member movement of the International Fellowship of Evangelical Students. Website: intervarsity.org

Unless otherwise noted, Scripture quotations are taken from the New Revised Standard Version of the Bible, Anglicized Edition, copyright © 1989, 1995 by the Division of Christian Education of the National Council of the Churches of Christ in the USA. Used by permission. All rights reserved.

The Scripture quotation marked NEB is from the New English Bible, copyright © The Delegates of the Oxford University Press and The Syndics of Cambridge University Press, 1961, 1970. Used by permission.

The Scripture quotation marked REB is from the Revised English Bible, copyright © Oxford University Press and Cambridge University Press 1989.

Interior design: © SPCK

USA ISBN 978-1-5140-0427-2 (print)
UK ISBN 978-0-281-08525-5 (print)
UK ISBN 978-0-281-08580-4 (digital)

Typeset by The Book Guild Ltd, Leicester, UK
Printed and bound in Turkey ∞

InterVarsity Press is committed to ecological stewardship and to the conservation of natural resources in all our operations. This book was printed using sustainably sourced paper.

British Library Cataloguing-in-Publication Data
A catalogue record for this book is available from the British Library

Library of Congress Cataloging-in-Publication Data
A catalog record for this book is available from the Library of Congress.

P 25 24 23 22 21 20 19 18 17 16 15 14 13 12 11 10 9 8 7 6 5 4 3 2 1
Y 36 35 34 33 32 31 30 29 28 27 26 25 24 23 22 21

CONTENTS

FOREWORD

Sister Wendy Beckett dedicated her life to meditation, contemplation and prayer. Whether examining an age-old painting or gazing upon the natural world around her, she looked for beauty and through it found God. Notoriously self-deprecating, she would surely flinch at the praise I want to heap on her. But she deserves celebrating. A fiercely intelligent woman with a singular ability to communicate, she was full of the joy she found in everything around her. Indeed, she was dedicated to joy as a means of understanding the goodness of God, writing: 'although we cannot command it, we choose joy, making a deliberate commitment to happiness.'[1]

Her pathway to joy, however, may seem unusual since she was at her happiest while alone, living as a hermit. In many ways Sister Wendy reminds me of the medieval anchorite Julian of Norwich. Julian also chose a life of isolation from others, being walled up in a single room for decades. Within those four walls she wrote the first known book in English by a woman, *The Revelations of Divine Love*. It is an extraordinary work of hope, positivity and solace, penned against the backdrop of the Black Death, heresy trials and war. Her words, 'All shall be well, all shall be well, and all manner of things shall be well' are still a source of consolation to millions some six centuries after her death.

The words of Julian of Norwich and Sister Wendy both resonate with positivity. While many might find the thought of isolation terrifying, these women used their solitude to probe deeply into the wonders of creation, the sacrifice of Christ, and the love of God for every individual. Sister Wendy was not content, however, to simply write down her thoughts. Instead she went out into the world to share her passions.

When I was younger, Sister Wendy's art programmes were an inspiration to me. Her ability to read a painting, and through it reveal so much more in terms of emotion, meaning and symbolism, was a revelation. She showed me that art is humanity's way of trying to picture

the transcendent, and so my own love of art history was born. She also enabled me to see my desire for intellectual nourishment as something to celebrate, with encouragement like this: 'We were created to be fully human and using our minds intelligently and reverently is essential to full humanhood.'[2]

I followed in Sister Wendy's footsteps, studying English Literature at St Anne's – the Oxford College she attended. But while I share her love of art and literature, I fear I am no match to her intellect, devotion and generosity of spirit. While reminding us of Christ's commitment to saving each individual through his death on the cross, these Easter meditations also prompt us to thank God for Sister Wendy. She dedicated her life to love, beauty, hope and above all to joy.

Sister Wendy's joy in the beauty and power of great art lives on in this lovely book, and in the many other writings she has given us.

Dr Janina Ramirez FRSA
Art historian and broadcaster

1 *The Art of Lent* (SPCK, 2017), p. 54.
2 *Speaking to the Heart* (Constable, 2006).

COPYRIGHT ACKNOWLEDGEMENTS

The Art of Holy Week and Easter

'This is My Body'

*Entrance into
Jerusalem,*
18th-century
Romanian

The entry of Jesus into Jerusalem, commonly known as Palm Sunday, marks the beginning of Holy Week.

Official visits to a city, by an emperor or some high dignitary, were occasions for a civic procession. The emperor would ride in, the officials would greet him, the people would applaud. When Jesus enters Jerusalem, it is almost in parody of such imperial pomp. He wears simple clothes, he carries no sceptre but holds the book of the Bible, his steed is a rather insignificant donkey.

What makes this icon so appealing is the look on the Lord's face. He is half-smiling, wholly benign, his long and beautiful countenance gleaming with the light of his divinity. This day of seeming triumph must have been a bittersweet experience for him. Within a few days the crowds that acclaim him would be urging Pilate to crucify him. Jesus looks neither to the apostles nor to the city officials, although he lifts his hand in blessing. He seems to be looking within, aware only of the Father, and wryly cognisant of the ephemeral nature of popularity. He does not wish men and women to accept him on a great surge of emotion. That will not last. The true 'Hosanna' can spring only from a heart that chooses, whatever the emotions, to believe and to trust.

Jesus is riding, or rather being carried, to what he knows is his death. He accepts what is to come as the inevitable result of who he is. There is grace in abundance for all who will accept it, but he is sadly aware that there will be few. Even the donkey droops his head compassionately.

Blake himself was more ambivalent about the interaction of divine and human creativity. For him, this picture might illustrate his sense that the divine is opposed to human flourishing. He wrote: 'And Priests in black gowns, were walking their rounds, And binding with briars, my joys & desires.' Then the reaching compasses become threatening, rather than full of potential.

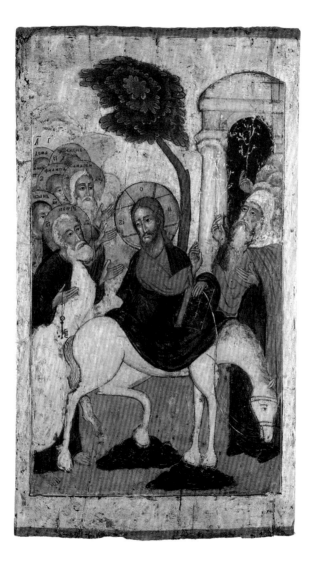

*Christ Driving
the Traders from
the Temple,
c. 1645–50,
Bernardo Cavallino*

In the Gospels we are told that Christ gathered cords into a whip and drove out of his Father's temple the money-changers and the traders. This act of passionate protest fascinates Cavallino. Christ stands at the centre of the picture, emphasized by the great pillar behind him. On either side, the traders and the money-changers fold away like playing cards, overcome by the divine indignation.

Cavallino imagines the reality of the scene: the shock and confusion of the traders, the money spilling out over the floor, the animals being huddled away into cages and baskets, and the beggars watching in amazement. The artist's desire for authenticity, to involve the viewer emotionally in the scene, conveys something of the passion with which Christ acted.

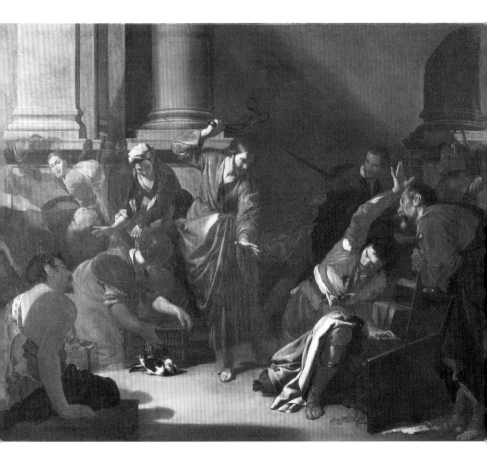

THREE

Jesus washes
his disciples'
feet

*Jesus Washes
the Feet of the
Disciples,* 13th
century

At the Last Supper, before they sat down together, Jesus washed the disciples' feet. In dusty Palestine it was customary to have one's dirty feet washed before a meal, but it was the job of a servant or a slave. It was inconceivable to the apostles that Jesus himself, their 'Lord and Master', should do something so menial. They are almost angry and Jesus wants to show them that this violent reaction comes from a misunderstanding of what it is to be 'servant'.

Everyone is called upon to be a servant, metaphorically to wash the feet of others. There is no indignity in it. In fact, it is part of the dignity of being a Christian, that we serve our neighbour in whatever way is needed. Unless we are self-forgetful, unless we think of others' needs, we are not followers of Jesus.

Here, the apostles are being washed in preparation for their receiving of the body and blood of the Lord. When Peter objects to having his feet washed, Jesus tells him that no one can have 'part of him', unless they are 'clean'. The icon shows Peter distressed by this gentle rebuke, offering to be washed from head down, while Jesus explains that the feet are enough.

There are two lessons in humility here. The first is that we must subordinate ourselves to the needs of others. The second is to accept that we need cleansing. Today it is the Sacrament of Reconciliation that does for the repentant Christian what Jesus is here doing for the apostles. There is only joy and gratitude in this Sacrament, and here we see Peter entering into the mystery of the love of God, fresh, clean, made ready.

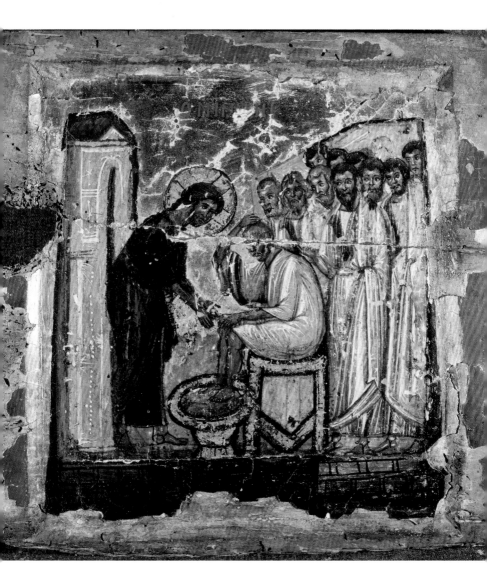

The Last Supper,
1494–1502,
Monte di Giovanni
di Miniato di
Gherardo, Missal,
Florence

In this picture the artist has tried to include four different events of Passiontide. Inset into the back wall is a brightly coloured representation of Palm Sunday. In the centre are shown two stages in the Last Supper itself. We see Jesus still at table, blessing the bread, with John leaning on his shoulder and Judas hostile on the opposite side of the table. In the foreground of the major image we have Jesus feeding his friends on this sacred and mysterious food. Below, we see the Lord agonizing in the garden of Gethsemane later that night, while Judas creeps on stage with the band of soldiers who will arrest him.

All around the margin of the picture are hosts and chalices, interspersed with grieving angels who bear lilies and lighted candles. The symbolism is dense, and this may be apt in its heaviness. These Holy Thursday events are too weighty to be analysed easily. The only genuine response is to pray, to unite with the suffering Jesus and to affirm our faith in his life and death. This is what his birth, in all its simplicity and joy, leads up to. Death is, after all, implicit in birth, and as far as the pain of death or the body's dispossession goes, Jesus did indeed die. The gift of his body and blood, given as food and drink, was made while he was still alive. It was an offering, a gift of himself, not an involuntary wrenching away from life, as death usually seems for us.

The theme may be tragic, but this picture communicates an inner hopefulness through colour. The brilliant yellows, blues, reds and the dazzling white all speak of triumph, not defeat.

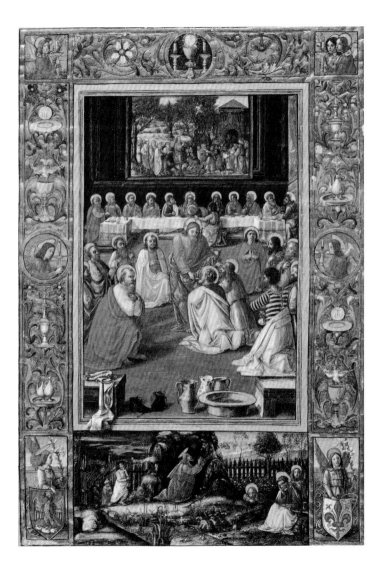

The Last Supper,
1464–67, Dieric
Bouts

Dieric Bouts has designed *The Last Supper* with such skilful zeal that the sheer patterning seems to outweigh the significance of what is happening. By the convergence of the central beam of the ceiling and the chandelier, the eye is led down the central line of the panelled door, and we are focused on Christ. The perfect symmetry of the room, with its austere and lofty Gothic architecture, heightens the impression that we are witnessing a moment of stillness. This is Jesus at the point when he institutes the Holy Communion – an event of enormous solemnity, which might well have frozen the apostles into attitudes of awe and wonder. Indeed, the disciples seem almost formulaic in their silence and stillness. It is a deeply theological picture, in which the apostles' relative impassivity is meant to indicate that they are meditating on the miracle rather than denoting indifference.

Judas, that angry black-and-red cut-out in the foreground, seems consumed with the only emotion that we can see. He is bitter, and will reject the gift that Jesus so trustfully will offer to his friends.

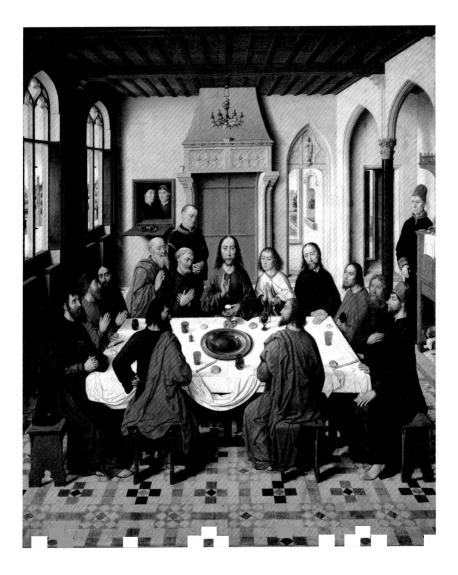

SIX

'I am the
true vine'

*Christ the True
Vine*, late 16th
century

At the Last Supper Jesus tells his apostles: 'I am the true Vine, and My Father is the Vine dresser. Every branch of mine that bears no fruit, he takes away, and every branch that does bear fruit he prunes so that it bears more fruit.'

He stresses this metaphor, 'I am the Vine and you are the branches.' Jesus is telling us that his eucharistic gift of himself so unites us to him that we too are part of 'the true vine'. It is only if we 'bear no fruit', if we will not receive the sap of love that gives life to the vine, that the Father will cut us away. He also warns us, of course, that when we receive this holy sap, and 'bear fruit', the heavenly vine dresser is not complacent. He will 'prune' us always out of love, so that we will bear 'more fruit'.

This beautiful icon shows Jesus holding an open Gospel on his knees so as to leave both arms free for a wide gesture of blessing. The vine has twelve shoots, rich with leaf and grape, and on the branches sit the apostles. Closest to Jesus are St Peter and St Paul. Prolonged contemplation of the icon will make it possible to identify each apostle.

This is the secret truth of the Church, that it is indeed a holy vine springing from the presence of the Eternal Jesus. This is not the Church which we see, the bedraggled and all too human Church, slowly learning to enter into 'the mind of Christ'. Humanly, this Church does not seem intimately united with Jesus. But that is only humanly speaking. In the light of eternity, this is a true icon summoning us to enter into its holy truth.

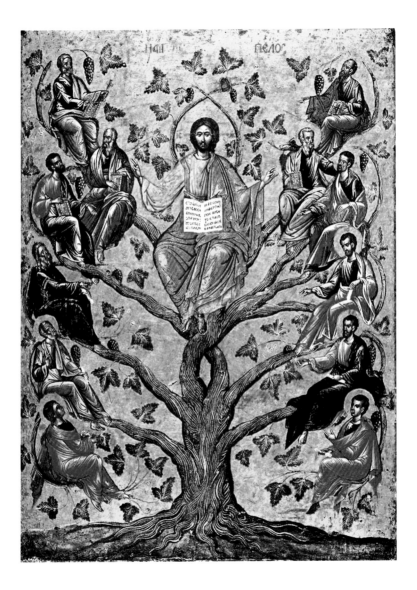

In the
Garden of
Gethsemane

*Christ in the
Garden of Olives,
c. 1500, Sandro
Botticelli*

After the Last Supper, Jesus led his disciples to the Garden of Gethsemane. He intended to spend the night in prayer, as he often did, but for once he asked three of the apostles, Peter, James and John, to stay with him. Here we see the loneliness of Jesus. He had never needed support, and now that he did, and was asking for it, the apostles were too insensitive to realize his inner suffering.

He went alone to pray, to wrestle with the certainty of the terrible death that was only hours away. Humanly, it would have helped him to be joined in this prayer by his friends. Botticelli makes it painfully clear that the friends are wholly oblivious – they have gone to sleep. Jesus is alone and isolated, fenced off from all human support. The Gospels tell us occasionally of Jesus' emotions: he could be angry, he could be distressed, he could be full of joy. But this is the one sole time when he was in anguish, sweating heavily under the sheer pressure of his desire to continue his apostolate and yet to be obedient to his beloved Father.

Sometimes we are given the impression that the saints are glad to suffer, that it is a mark of their sanctity. But the saint of saints, Jesus himself, saw suffering and torture and cruelty for what they were: hideous and evil. There is great comfort for us weak sinners in the agony in the garden. The only thing Jesus wanted was his Father's will: please God, that is what we want too. His Father sent an angel to strengthen him, and in one form or another, his Father will send his angel to strengthen us.

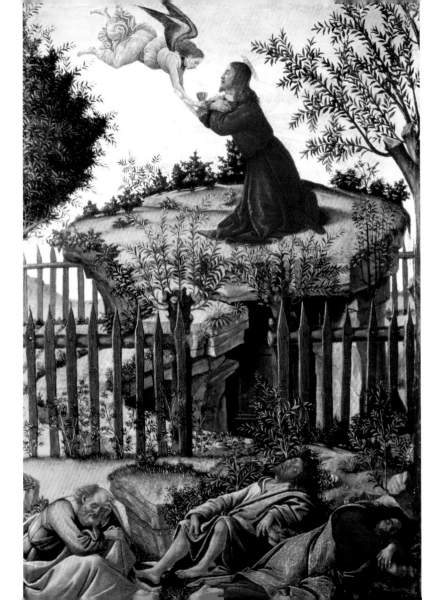

'Behold the man!'

Judas
betrays Jesus

*The Taking
of Christ,
c. 1602,
Caravaggio*

The taking of Christ is a violent picture. Caravaggio depicts every actor in this scene as emotionally distraught – all except for Jesus. The disciples flee in open-mouthed terror, the soldiers surge forward angrily intent on seizure, Judas grasps his Lord grimly and terribly, intent upon betrayal. Only Jesus stays quiet.

We are shown distorted faces and bewildered faces: the soldiers clearly do not fully grasp what they are doing. But the sad face of the central figure, pushed to one side, but inherently central, is remote in silent prayer. Jesus grieves, not only for himself, but for the friend who has sacrificed his own wholeness in sacrificing Jesus. Caravaggio tells the story partly through faces but even more through hands. The highest point in the painting is an aggressive hand, and a hand raised in blind fear comes just below, which is of significance.

In the middle area are the hand of Judas, digging fiercely into Jesus' arm, and the overlaid hand, non-human in its steel protection, of the arresting officer. This man dominates the foreground, almost faceless, like a huge beetle, destroying what it catches. But right at the bottom, strongly lit, are the linked hands of Jesus, resolute in non-resistance, tense but peaceful, hands braced to receive what the Father allows to happen. It is this painful but total obedience that is most integral to the meaning of Jesus. His eyes are not set on any outward happening, only on the presence within of the silent Spirit.

The turmoil of life is not something to be escaped, but to be used. Caught in the net of malice, Jesus waits in patience for his deliverance, not from disaster but through it. In him, we too are free when entrapped, empowered to make all our distress a holy purification.

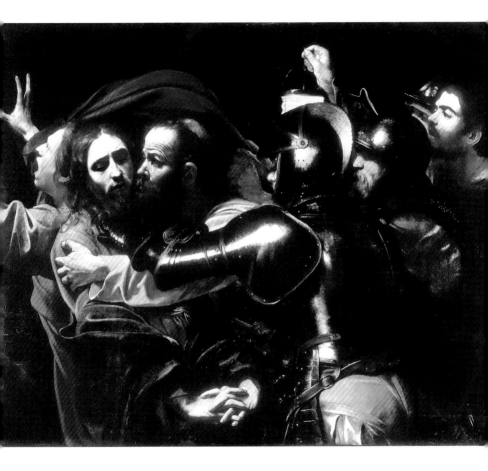

*Christ Before the
High Priest,
c.* 1617, Gerrit
van Honthorst

Gerrit van Honthorst was one of several Dutch artists who travelled to Italy to study art and was profoundly influenced by his experience. Caravaggio's paintings showed Honthorst the dramatic possibilities of light and shade and he developed a great skill for painting dramatically lit night scenes. *Christ Before the High Priest* was a celebrated painting in its own day, deservedly so, as it may well be his masterpiece in this genre. The candle spotlights the warning finger of the High Priest, who colludes with authority and the powers invested in him to harangue and condemn the Son of God, who stands with patience and humility before him.

The two protagonists, the High Priest and Christ, are brought to our attention by the candlelight that falls on their faces, hands, and garments. All the other people witnessing the event are obscured by the shadow of darkness. The two onlookers who stand behind the High Priest's chair (a reference, perhaps, to those false witnesses described in Matthew's Gospel) appear hostile and, in contrast to Christ, their expressions appear cynical.

Honthorst shows us an encounter between small-minded power and large-minded submission. The drama and the irony are both intense, yet the artist does not overplay the deeper significance of the event. Instead, he uses his understanding of light and shadow to present a confrontation, the outcome of which we know. He leaves us to experience the subtle nuances of atmosphere and character that he lays out before us.

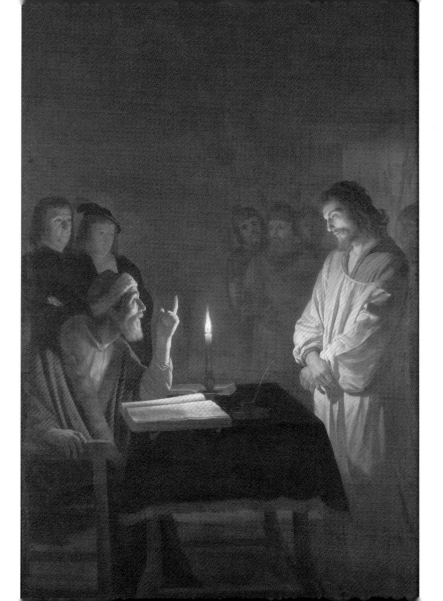

TEN

Peter denies
Jesus

*The Prediction
of Peter's Denial,*
1420–30, Anon.,
*The Office of the
Blessed Virgin
Mary,* Florence

When Jesus is betrayed, Judas is the villain and Peter, in his own eyes at least, is the hero. His impulsive and ill-judged swipe with a sword is the only 'defence' that Jesus receives. But it is short-lived. Peter is inconsistent – in fighting mode one minute, and in the next he is for flight, joining the other apostles in their swift retreat. But he cannot stay away from his Lord Jesus. His devotion, however flawed, is genuine, and he must have remembered often how he had boasted to Jesus that 'even if all betray you, I will never betray you'. Jesus told him (we can imagine he spoke with a wry smile) that 'before the cock crows twice, you will deny me three times'.

This poignant little picture shows us the crowing cock in his triumph and Peter, no longer crowing, in his disgrace. He did indeed deny his master, three times insisting to the servant girl in the courtyard of the High Priest's house that he knew nothing of Jesus. His Galilean accent gave him away, and Peter, terrified, denied the servant girl's accusations again and again.

The artist depicts the servant as essentially unmalicious, merely a sceptical young woman who knows a liar when she sees one. Peter counters her hand language with furious vigour, 'cursing and swearing'.

Peter will soon hear that accusatory crowing, will suddenly realize what he has done and will be overwhelmed by bitter sorrow. Yet it is this moment of shame, at the faint threat of a slender young woman, both charming and harmless, that finally and forever alerts Peter to the truth of his own weakness. Here he touches bottom, and yet we notice that the artist still – and rightly – shows him with a halo, tattered but nevertheless real.

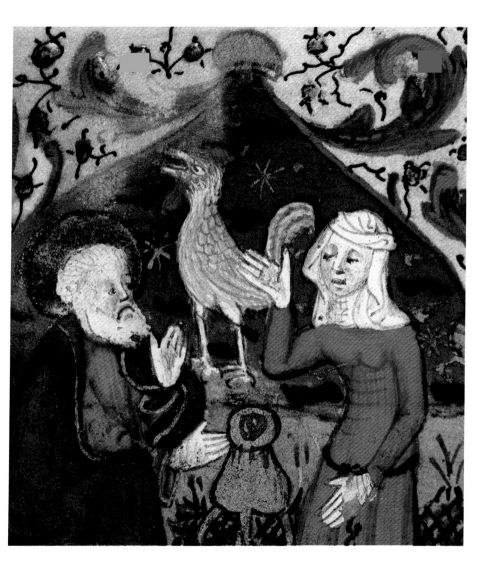

ELEVEN

Peter's
repentance

*Peter's Repentance
(Concerning the
Life of St Joachim),*
1476, Cristoforo de
Predis

The famous scene in the garden courtyard, where Peter three times vehemently denied that he had any knowledge of Jesus, ended when the guards brought their prisoner out. St Luke tells us 'the Lord turned and looked at Peter, and he remembered'. The Gospel continues sadly: 'and he went out and wept bitterly'.

This magical little picture presents an unforgettable image of grief. It is that most painful kind of grief, lamenting of our own folly. Here we see Peter with his shamed face covered, stumbling blindly forward from one closed door to the next. There are ways out behind him, but Peter is too lost in misery to look for them. This claustrophobic despair, this helpless anguish, this incapacitating sense of shame: these are the result of a sudden overturn of our own self-image.

Peter had honestly seen himself as one who loved and followed Jesus, priding himself, moreover, on how true his loyalty was in comparison with that of others. 'Even if all should betray you, I will never betray you' – it was a boast, but he had meant it. Now he sees, piercingly, that he is fraudulent. He has been unmasked to himself, he has lost his self-worth.

The crucial question is: what next? Will he hide his face forever, destroyed by self-pity? Will he lose all heart, perhaps even kill himself, as Judas did? But while Judas felt only remorse, Peter feels contrition, a healing sorrow that will lead to repentance and a change of heart. Now that he knows his true weakness, he will cling to Jesus as never before. He will cling in desperate need and not in false strength, and will in the end become truly Peter, the 'rock', on which the Church, likewise dependent on Christ, will be built.

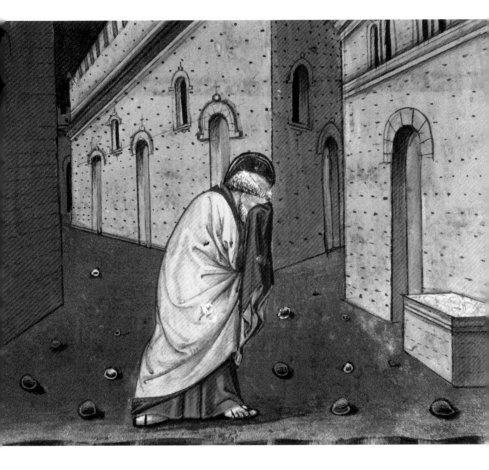

*Christ Before
Pilate,* 16th
century

Christ before Pilate is one of great confrontations of history. In fact, it is 'the confrontation', the only time when the pure power of the Spirit, incarnate, faced the pure power of the world. Pilate represents the greatest secular power that humanity was to know for many centuries. Over his head is the scarlet canopy of Imperial might and he is dressed appropriately for his rank. The solidity of the architectural background is symbolic of all the armies and treasuries and judicial courts that back up his position.

In this sense Jesus has no power: he has nothing material behind him. As he tells Pilate, 'My kingdom is not of this world.' In becoming human, the Son of God has chosen to become 'a common man'. He is poor, living his life in a small, unimportant country, unable to impose his will. Power is all about imposing one's will: Jesus forgoes this. He will never force. He wants followers who will choose to obey, who will use their freewill to reach out of their creaturely inadequacies to the transforming love of God.

Here, Jesus has been brought before Pilate as a condemned criminal: lowest of the low. Jesus will not accept the untruth of this. He is no criminal, and he defies Pilate to find a moral justification for his condemnation. On the other hand, Jesus is fully aware that 'authority' has been given to Pilate, in a worldly sense, and he is gently challenging this Roman governor to think for himself and make decisions according to his own conscience.

We grieve to see our Lord sent to his death by a weak and venal authority. All the countless multitudes who have been persecuted and misjudged throughout history find Jesus standing beside them.

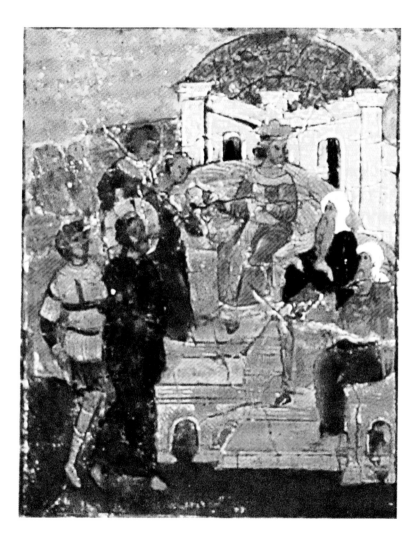

*Jesus is Stripped
of his Garments
II,* 1987, Albert
Herbert

One may define an artist as a human being who is forced to be truthful. An artist's conscious intentions are always at the mercy of inner necessity. Genuinely religious art either comes from a level beyond the artist's control, or it does not come at all.

Albert Herbert is a supreme example of this truth. *Jesus is Stripped of his Garments* is from a series of Stations of the Cross that Herbert made for a London church; they were rejected, and we can understand why. This image, arising from the depths of the artist's psyche, has a terrifying truth. Jesus is in a nightmarish situation, with leering faces of rejection of all sizes, all scornful, all powerful, ringing him in on every side.

Claw-like hands reach in to strip him; he experiences our ultimate fear: to be exposed to our mockers. Jesus is literally exposed; the enveloping garment of his public persona is being ripped away. The enemy exults and jeers. The slight and unheroic Jesus looks up at them, not in anger, far less in self-protective hate. He faces them bravely and nakedly. He enters into every creature's nightmare, not to triumph over it but to endure it and he accepts with courage his own stripping.

What makes this image so terrible, and surely why it was refused by its commissioners, is that the savage delight in the downfall of God and the greedy hands thrusting at his clothes are our own. It is we who do not want God to be God to us, who seek to undo his dignity and remake him in our own ugly image. We fail, and the Holy One who is stripped of his protections puts to us an unavoidable question: are you for me? Or against?

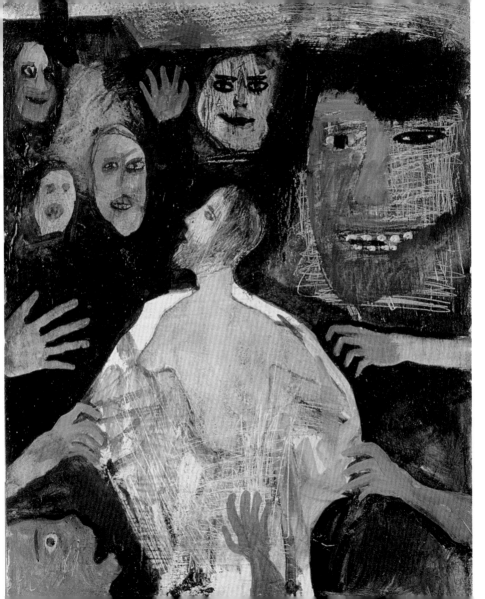

*The Mocking
of Christ,* 1865,
Edouard Manet

Manet was not what one would call a religious man. He was a wealthy bon vivant, a man about town, a dandy – but then I found a letter he wrote to his closest friend, in which he says that he always longed to paint an image of Christ on the cross. No images of heroism or love can compare, he writes, to that of suffering; and he adds, enigmatically, that suffering is 'the root of humanity, the poetry'. Literally, of course, this is hardly true, since animals also suffer, but I think he means that only humanity can consciously accept suffering, master it emotionally, and refuse to let it crush the spirit.

Manet found a perfect example of this inner strength in the story of Christ's passion. This scene, where the Roman soldiers, who have heard that Christ claims to be a king, amuse themselves by taunting him, was frequently painted. Christ was always shown as wholly beautiful and wholly good, whereas the soldiers were evil and ugly. In Manet's version, Christ is wholly good, but he is not beautiful. Manet caused great offence by using a workman as a model. We notice the knobbly legs, the misshapen feet, the scrawny body; this is a poor man, which is, of course, exactly what Christ the man was. The soldiers are neither evil nor ugly, but ordinary human beings (like the viewer) – baffled by the peace with which this tortured man endures. The one high point of colour is the scarf on the head of the soldier who looks out at us, meditating and wondering. I believe, unequivocally, that this is a great religious painting.

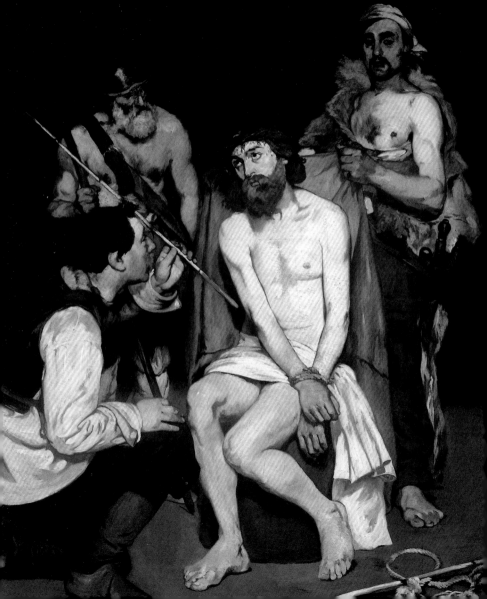

'Father, forgive them'

*Crucifixion,
c. 1510, Mathis
Grünewald*

There are many versions of the Crucifixion undertaken by some of the greatest artists in history, but the central panel of the *Isenheim Altarpiece* is unique in its depiction of Christ's suffering. Grünewald painted this image for the hospital at Isenheim, which cared specifically for those suffering from leprosy, the scourge of the Middle Ages. Here, Christ is not only suffering from the torture of being nailed to the cross, but he also has leprosy. His skin is disfigured by green boils, and it is Grünewald's aim to offer an image of empathy and comfort to the hospital patients. The artist ventures into this abyss of sacred agony with terrifying realism.

Grünewald is hammering home the stark message that it is this Jesus, this despised and tortured man, that Christians must accept as their role model and saviour. This is a truly medieval painting in sentiment – even the background is a sea of desolation, with no comfort but that of faith.

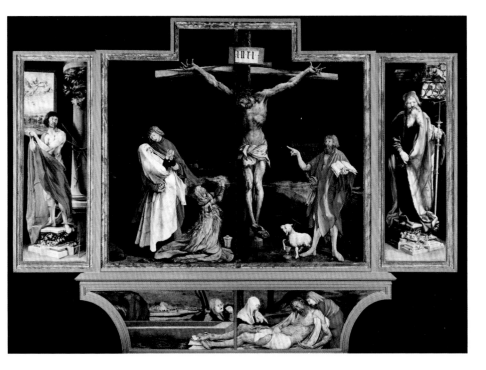

SIXTEEN

Crucifixion: II

Christ on
the Cross,
c. 1600–10, El
Greco

Christ on the Cross by El Greco is an astonishment and a delight to me, because here – and this for me is unique – I find the Passion understood rather than just shown.

It was a transforming moment in my life when I, who had always found Holy Week and Good Friday almost unendurable, suddenly saw that, in fact, Jesus died in an ecstasy of joy. He had been sent by the Father to bring life into the world. He had done it, achieved what the Father intended. His agony, physically and emotionally, may not have been any the less, but in his will Jesus knew the great liberation of having reached an almost impossible goal.

All this I see, mystically, in El Greco. The intensity of the surrounding, enveloping darkness – the moral darkness of a human system that could torture anyone to death, innocent or not – is just beginning to be pierced by the radiance that Jesus has brought. That sharp and by no means comforting light shines on the scattered bones of other men who lie scorned beneath the cross. It spotlights the wealth and power of established authority as its representatives depart, the knights on horseback with flowing banner, and emphasizes the solitude of the Lord.

El Greco does not alleviate his sacrifice with grieving family and friends. No, Jesus dies alone with his God. He dies looking upwards, his determination set upon his Father's will and its consummation. But the most marvellous touch, to me, is the depiction of the dying Jesus as already triumphant over death: he does not escape death; he passes through it and out of it. His body spirals upwards like a white flame, radiating out as he spreads his arms to share the light with the defeated shadows.

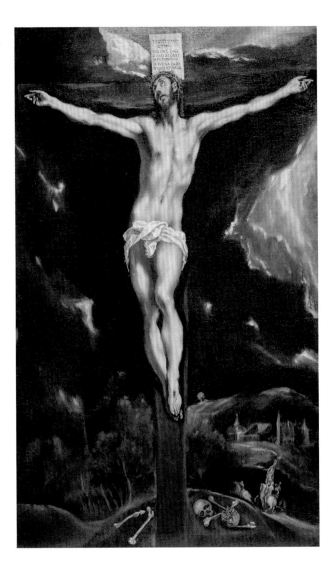

If I were trying to explain this picture to those who had never heard of Christianity, I would tell them to regard it as a great meditation upon the meaning of death. It is centred on a depiction of three ways of dying.

On the right we have one of the two thieves who were crucified with Christ, the so-called 'bad thief'. He has been called this because he died badly. He died raging against death, closed up in himself and his own bitterness and frustrations, hostile to everyone and aware only of himself. He went screaming into eternity; please God none of us die like that.

On the left is the 'good thief', good because he died trying to do a kindness to another. The good thief spent his last breath saying, out of compassionate concern, 'Lord, remember me when you come into your kingdom.' The dying Jesus raised his head and replied, 'This day you will be with me in paradise,' and the good thief slipped happily and sweetly out of life. This is the death we all desire, a death of unselfishness and of peace.

In *The Lance*, Jesus is already dead; his last words, said just before his side was pierced by the lance to prove that he was now bloodless, are hard to translate: *Consummatum est* in Latin, something like 'It is done, absolutely everything has been given' in English. To have achieved the utter fulfilment of all potential, to have become completely human: would that we could die like that.

Around the three who are dead or dying are three other groups of three. The executioners, astonished and active; the mourners, passive in the intensity of grief; and the interconnecting group of Magdalene and the bystanders: us.

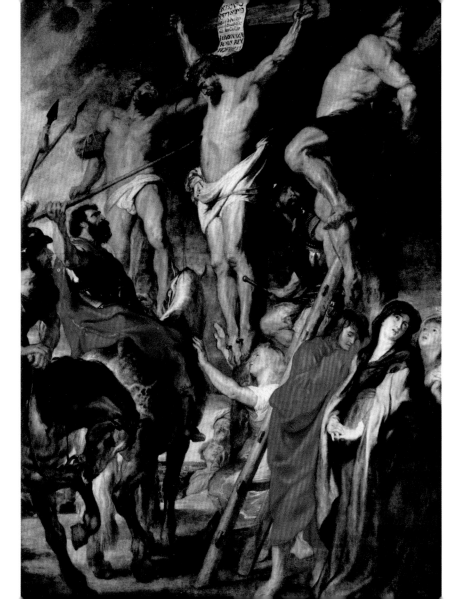

*The Lamentation
of Christ, c.* 1305,
Giotto di Bondone

In one very real way, Western art began with Giotto. After the delicate traceries of Gothic art, Giotto's revolution shocked artists into an awareness of the solidity of the body, of how human emotions were expressed through that body and, most of all, of the artist's ability to communicate this in a way that involved the spectator in the reality of the scene.

Giotto's great opportunity came with the commission to decorate two windowless walls of a small chapel in Padua with scenes from the lives of Christ and Mary. Everybody who saw *The Lamentation of Christ* on the chapel walls would have known the story well – that Jesus had died on the Cross and that a profound sorrow ensued. Giotto took that intellectual conviction and made it throb in the nerves. He involved the spectators and showed them that the people in the Gospel story were people just as they were, emotionally fraught as they attempted to express their grief.

Here, Giotto brings to life the painful reality of a death. Before we can reach the dead body of Jesus we must bypass the great hulks of two figures who sit cloaked and mourning. They give depth to the work and draw us in to Jesus and his mother.

Each person responds in accordance with his or her own temperament. Mary is intent and questioning; Mary Magdalene, seated at his feet, is weeping; and St John stretches out his hands, apparently with an incredulous cry of grief.

Giotto does not depict only human pain; a great rocky diagonal leads up to a bare tree, linking the foreground scene to the extraordinary lamentations of the angels, fizzing and swooping in an acrobatic crescendo of heavenly sorrow.

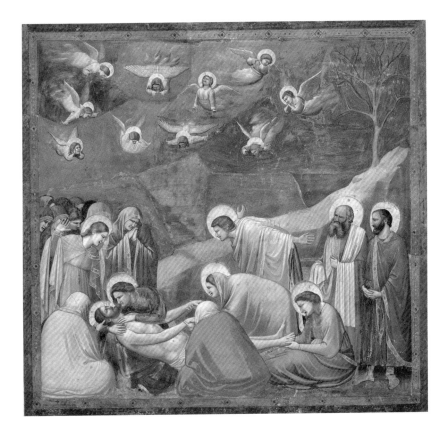

NINETEEN

Jesus is
mourned
by Mary

*Mater Dolorosa,
c.* 1570, Luís de
Morales

Luís de Morales was also known as '*Il Divino*' (the Divine One) because his devotional paintings, such as *Mater Dolorosa*, were so pious and spiritually affecting.

The colours de Morales has used here are extraordinarily subtle – the faintest of blues and purples, bleached yellows, and an almost translucent white – all set against a dark, sombre background that reinforces the idea of human tragedy.

His depiction of Mary is peculiar to him: the face is exceptionally long and thin, as if worn down by sorrows; the cheeks are hollowed; and the eyes are deeply recessed and shadowed. Mary's beauty is indestructible, but pain has diminished it.

Perhaps this is clearest in the anguished hands, which are as expressive of grief as the face itself. The long, bony fingers are thrust out at us with an almost surrealistic passion, bringing to mind the legs of a frantic crab or some other such scurrying creature. Those anxious fingers speak more loudly of her inner tension than the quivering lips or the hunched and tense shoulders. While her hands are held towards us, Mary looks away, her eyes cast down to the dead son that we cannot see.

Apart from those tensely clenched fingers, Mary's emotions make no overt display. This stillness – this compressed intensity – is far more evocative of grief than the melodramatics of de Morales's Italian contemporaries. Here is a woman who is almost incandescent with her sorrow.

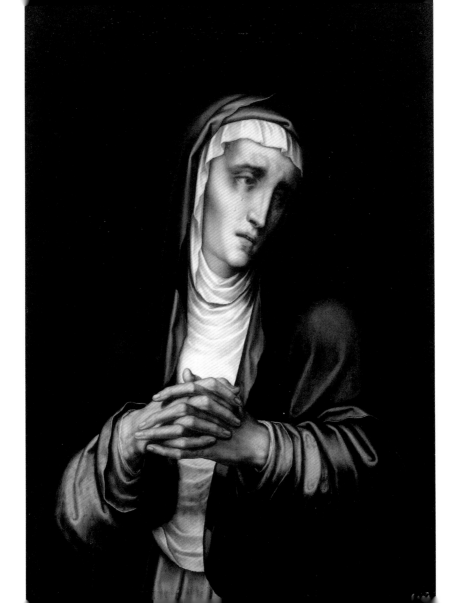

TWENTY

The
entombment

*Entombment (or
Pietà),* 1576, Titian

When Titian painted the *Entombment*, the plague was raging in Venice. The consciousness of death must have been on everyone's mind, and perhaps specially on Titian's, because he was very old. This work seems to be, in a way, his testimony to the world, this painting of the dead Christ and the living Mary, so silent and contained, yet somehow so united with her son in love.

There are two other central figures. One is Mary Magdalene, wild with grief, painted with enormous passion. She is fiercely angry about death: death is hateful, we are not meant for it. But on the other side of Christ is a very old man, coming as if in his second childhood on hands and knees. This is a self-portrait of the old Titian, affirming both his faith and his need of divine forgiveness.

The tomb where Christ will lie is a grand Renaissance construction, with dimly glimpsed statues on either side and a strange, almost hallucinatory landscape setting.

At the right there is a strange hand reaching up out of nothing, groping for light, for help, for salvation. To make this explicit, Titian has painted beneath it a small ex voto (a painted panel put on an altar as a silent prayer). In it Titian shows himself and his son Orazio on their knees, imploring deliverance from the epidemic. But before this painting reached the church, both of them were dead – of plague.

Was his prayer unanswered, his passion wasted? At the deepest level, the answer is no, because his passion has overcome death, drawing life out of darkness and wringing hope out of despair. In the purity of its beauty alone the *Entombment* celebrates eternity, which is what painting is all about.

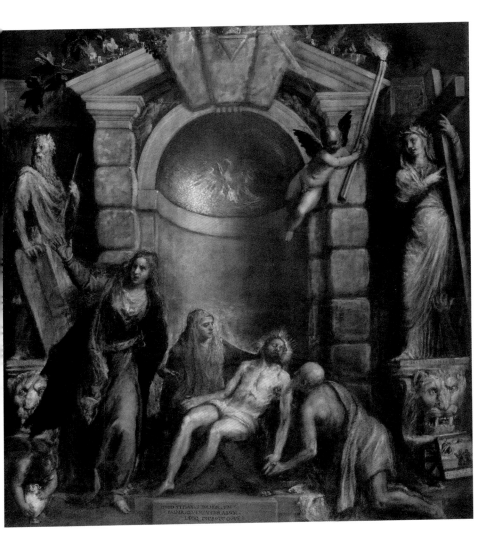

TWENTY-ONE

Jesus is
mourned
by angels

*The Dead Christ
Mourned by
Two Angels,
c. 1617–18,
Guercino*

Guercino is the most dramatic of artists. He has an instinctive feel for bodily and psychic reactions. We know he had a squint, because that's what his name means (*guercino*: squinty-eyed), but this defect never seems to have impeded his wonderful delight in the shapes and the colours that human beings provide in their interactions.

Christ Mourned by Two Angels is dramatic in the purest sense; Guercino is showing us the moment just before the dead body of Christ stirs and the resurrection has happened. Guercino is so often unusual, and here is a superb example. He shows us not the dead Christ, nor the risen Christ, but Christ at a moment in between, a moment on the brink of transformation. It is a supremely beautiful picture, where light and shade in themselves are used to tell a story; the darkness, the shadow, is passing away to the upper right and light is coming in, flooding over Jesus and calling him back to the warmth of the world.

The angels are puzzled; one in particular has a questioning look, marvelling at how the Son of God could have died as all men die. But it is the fine point of the uncertainty that gives this superb picture its particularly beautiful edge.

Unaware of what is to come, the angels' grieving faces are yet becoming luminous with the new life that is beginning to glow in Christ's body. The dead head is about to lift, and their profound sorrow is on the point of changing into an ecstasy of joy.

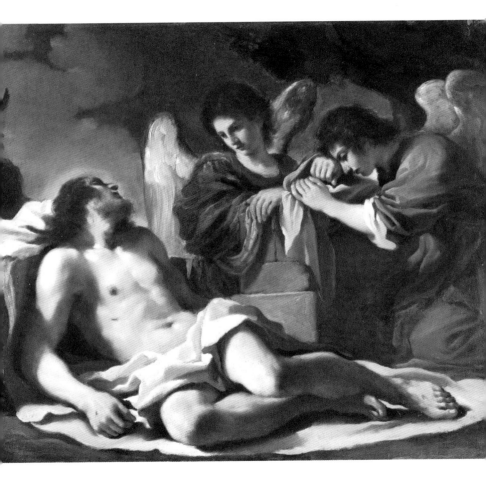

'He is risen!'

TWENTY-TWO

The descent
into hell

*The Descent into
hell,* 1502–3,
Workshop of
Dionysius

For the Orthodox Church, the classic image of the Resurrection is
not so much Jesus rising from the tomb, but of Jesus descending into
hell.

In the centre of this icon, translucent and beautiful, stands the
resurrected Jesus. He is tugging out from hell his human forebears,
Adam and Eve. Behind Adam stand David and Solomon wearing
their crowns, waiting their turn for deliverance. Behind Eve is John
the Baptist and, among others, Noah holding a small model of the
ark. The gates of hell have been shattered, rising like a drawbridge.

Beneath Jesus are the angels imprisoning the Devil who will never
again have the power to roam unfettered on the earth. Jesus has
conquered him. Behind the glowing angels in the centre, dimly
glimpsed in the darkness of the underworld are the vices, each
personified by a devil, and each pierced through by a beam of light
that comes from the angels who surround Jesus in the blue globe of
the world.

These supporting details are hard to read with clarity, but what is very
clear are the masses of the forgotten dead to right and to left clothed
in white and stretching out their hands in love and hope and desire.
Them too, all of them, the countless millions, Jesus will rescue from
the darkness and lead them into the light of his Father.

The icon is not so much concerned with what happened, that Jesus
rose from the dead, but what this means. It means that the power
of hell has been broken and that heaven is wide open to all who are
willing to receive God's love.

It is the choice of the will – to obey, to accept the Lord, or to turn
selfishly away from him, that determines our future.

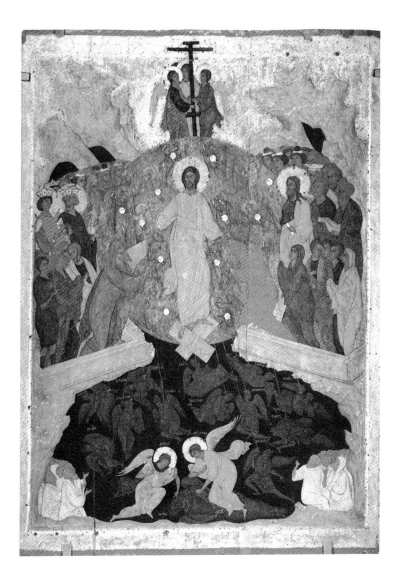

*The Holy Women
at Christ's
Sepulchre,* late
1590s, Annibale
Carracci

This image of the holy women coming to anoint the dead body of Christ on the morning of Easter Sunday, and being told by an angel that Christ has risen from his tomb, has an extraordinary weight to it. The figures loom out of the darkness with massive force, each woman individualized by the difference of her reaction to the bright and unearthly figure that imparts a message they cannot understand.

The woman on the left shrinks back in fear and bewilderment at the apparition; the central woman – the astonishing beauty of her profile outlined for us in shadow – moves forward with the most touching earnestness, intent only on finding the dead Christ. The woman nearest the angel seems to question him. She argues with him and implores him, refusing to accept the unacceptable – that Christ has gone.

The holy women live in the world of shadows; the angel, on the other hand, is all brightness, not because light falls on him but because light radiates from him. His finger points away, into the mystery of the resurrection.

Behind the women, the sun is rising and the world is beginning its activities. Here in the lonely garden at the stone sepulchre, silently and passionately, three mourning figures are trying to come to terms with the angel's message.

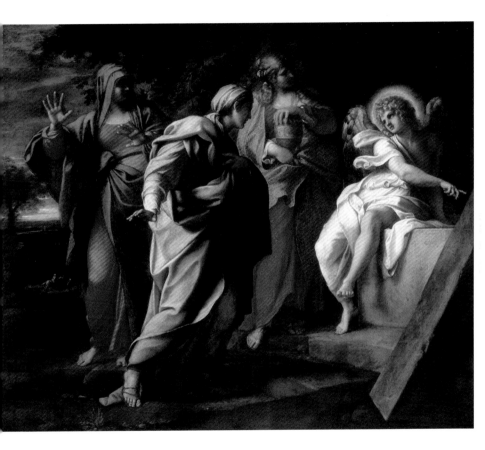

We know this is the empty tomb because it has 'sepulchre' inscribed within, in small, pathetic script. The Marys are likewise named, standing before the tomb with their useless jars of embalming ointment. But this is only a notional tomb, far too small to contain a human body, and it brings to mind two other suggestions.

One is that the oblong hollow, open at the top, even provided with what look uncommonly like feet, resembles a crib, the first bed of Jesus at his happy birth in the stable. Both at his birth and at his death, Christ's body was placed there by others and neither structure was to hold his body for long.

But the other possible interpretation is even more convincing, since it may well rest on an historical truth. This tomb calls to mind a tabernacle, the small receptacle in which consecrated bread lies, awaiting Communion time. Jesus in the form of bread is, supremely, the given Jesus, sacrificed for us and there for our taking. He had promised to be with us 'always, until the very end of time', and in the tabernacle that promise is visibly true. Jesus belongs to all, he is 'for us'.

The artist who created this haunting picture will have seen that empty tabernacle, a silent witness, and may have reproduced it here. The Marys are bewildered, unable to cope with circumstances beyond their expectation. They draw no sensible deduction and derive no comfort from the empty tomb. Theirs appears to be a narrow faith, that can seek for Christ only in the accustomed places, whereas he wants to strengthen our trust by extending the possibilities for finding his presence.

lapidem teuo greffe non In
luctum amonu uenefunat cor
mentato; eccIn puf dni Ihu:

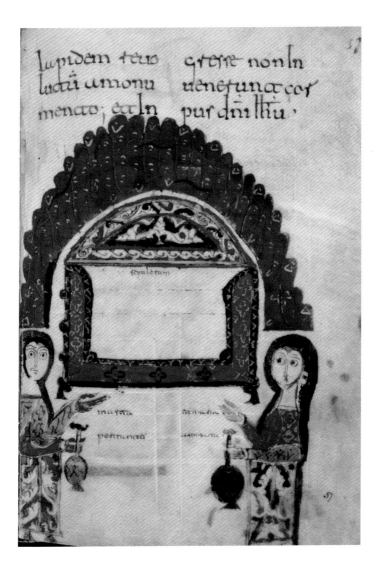

The Resurrection,
late 14th century,
Master of the
Třeboň Altarpiece

Nothing is known of the life of the Master of Třeboň. His name refers to Třeboň in the Czech Republic, one of the few places where his work – or, rather, fragments of his work – survived. The power and vitality of *The Resurrection* make us aware of just how much we have lost. It is a highly unusual image: the guards are not asleep, as Scripture suggests. If the guards were sleeping, they have woken in astonishment as the luminous vertical of Christ rises from the dead.

Christ's shroud is a vibrant vermillion that is echoed in the sky, spangled with golden stars, and in the livid wounds on his body. Raising his hand in benediction, he seems to have come through the stone of the sarcophagus, which remains resolutely shut, and he appears to be bringing the whole world of nature (the background is radiant with birds) into the freedom of his newly resurrected life.

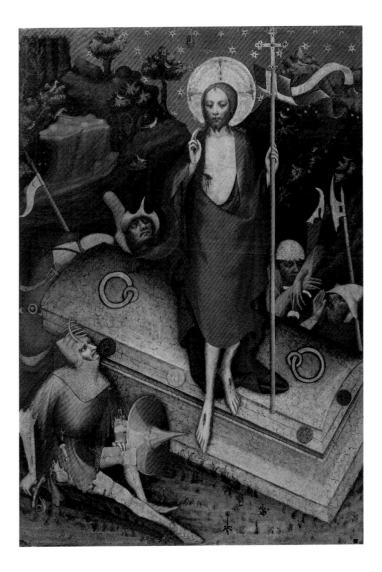

Resurrection,
c. 1463, Piero
della Francesca

It is hard to accept that for centuries Piero was forgotten, regarded, at the most, as a very minor Renaissance painter. Now he seems to us to loom effortlessly above the rest. No artist has ever rivalled the majesty of Piero, or achieved that sense of inner stillness that in our anxious times we find so deeply appealing.

Here is the risen Christ as the young hero; on his left, the bare trees of winter, on his right, leafed trees, called into fertility by the vitality of his risen presence. His is an implacable face, making no judgements, but in its austere purity perhaps calling us to judge ourselves. Piero softens the grand severity of the image by showing the blood-stained wound in Christ's side and, in a lighter mood, throwing around the heroic torso of his Christ a robe of the most delicate flowery-pink.

The four sleepers are monumental in their own right, and although Piero's main concern is to show the profundity of their slumber (which enabled the earth-shaking resurrection to take place unobserved), they also provide a human contrast to the physical glory of Jesus. Their muscular glory is unused, wasted; Christ stands erect, holds his banner, and is tense with restrained motion as he readies himself to rise and leave the tomb.

Each of the figures seems to be in a different degree of slumber: the man on the left could be rubbing his eyes, about to awake; equally, the man on his right is in a position that is not conducive to deep sleep. The man above him is not as deeply sunk in slumber as his hapless companion. Morally then, each of these men is more or less guilty of wilful ignorance of the event to which, physically, they are so close.

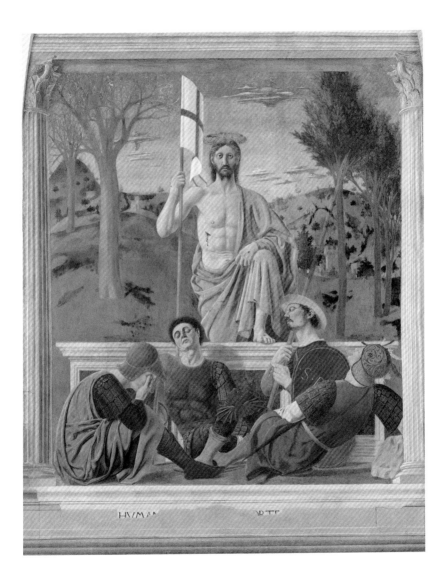

HVMAN ARTE

TWENTY-
SEVEN

'Do not
touch me'

Noli me tangere,
c. 1514, Titian

The heart of Mary Magdalene was broken by the death of Jesus, and all she could do to show her love was to prepare his body, wash and clean it, as this had not been done after his hurried burial. Her anguish when she finds even this last service is not possible comes across very clearly to us. The tomb is empty: 'They have taken away my Lord, and I do not know where they have laid him' (John 20.13).

Whoever searches, finds. Mary Magdalene does indeed find; she meets him, but she thinks he is the gardener, and Titian shows Jesus holding a hoe, which explains her mistake. One of the most moving passages in the whole of Scripture is when the so-called gardener turns to her and says, 'Mary.'

We know what happens next, how she drops to her knees, lifted in one moment from the depths of sorrow to the heights of joy. She stretches out her arms to him, and Jesus explains that this is his risen body, not to be touched – only to be adored and loved and praised. *'Noli me tangere,'* he says, 'Do not touch me.' So, piercing through her ecstatic joy comes the pain of reality.

Noli me tangere shows the youthful Titian delighting in the human interplay between the ardent Magdalene, all rich and spreading drapery, and the austere Christ, who withdraws from her with infinite courtesy. Christ almost dances in resurrection freedom; she is recumbent with the heaviness of earthly involvements. A little tree tells us that newness of life has only just begun, and a great world stretches away towards the blue hills, remote, witnessing, leaving Mary Magdalene to her own choices.

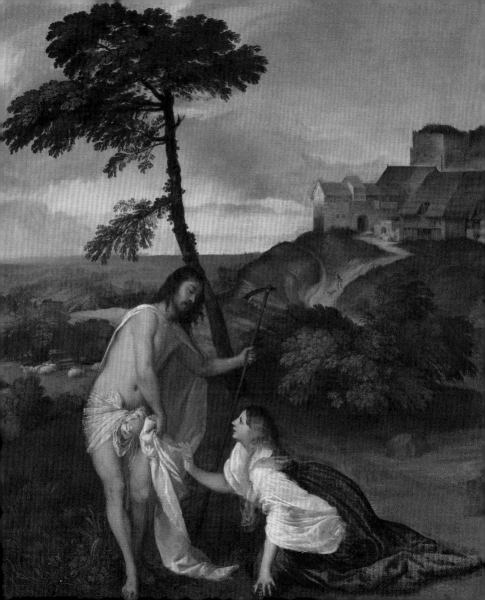

*The Supper at
Emmaus,* 1601,
Caravaggio

As they drew nearer to Emmaus, the stranger who was accompanying the two disciples made as if to leave them. They begged him to join them for supper. No artist, no mind however imaginative, can picture the appearance of one who has risen from the dead. These two did not recognize Jesus; they only begged him to stay because they were so engrossed by his conversation. It was only when they sat together at table and Jesus blessed the bread and broke it, that they suddenly recognized what must have been a characteristic gesture.

Breaking the bread and blessing it: that is the eucharist. It is how the eucharist is celebrated to this day, and always will be. For us too, Jesus reveals himself in the 'breaking of the bread', though as we expect it, we are not astonished as are these two disciples. Better perhaps if we did feel astonishment, because the eucharistic sacrifice is the most overwhelming of sacred gifts.

Caravaggio does not paint Jesus as is customary, lightly bearded, grave and compassionate of face. That Jesus they would have recognized. But this is a Jesus who is eternally young, though still utterly the same.

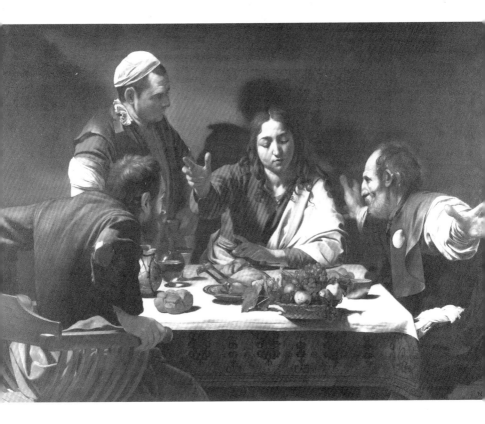

TWENTY-NINE

Doubting
Thomas

*The Incredulity
of Thomas,*
16th century

After the disaster of Calvary, the disciples had hidden away in an upper room. They were very careful to shut all the doors. This icon shows us that solid metallic door, through which Jesus passed. His was a Resurrection body. No doors could hinder his freedom. It took some time before the bewildered apostles realised that there was no call for mourning but rather for an astonished joy.

However, when Jesus appeared to them, one apostle was missing, Thomas. Thomas regarded their description of their experience as a pathetic example of wishful thinking. However earnestly the others assured him that Jesus was not dead, Thomas was adamant he would not believe.

A week to the day, 'the doors being shut', Jesus materialised again. This time, Thomas was present. The icon shows Jesus standing on a small rostrum, as if the apostles had prepared a sacred space in the hope that he would visit them once again. Jesus singles out Thomas and tells his doubting follower to come close and to put his finger into the wounds. Jesus tells him gently, 'You believe because you have seen me Thomas,' and then gives us, who have never had this experience, our glorious tribute: 'Blessed are those who have not seen me and yet believe.'

Doubt is not a dead end. It can lead to an intensification of faith. It was not the other apostles, standing reverently on either side, who acclaimed Jesus with the words 'my Lord and my God'. Had they realised, at last, that Jesus was truly God as well as truly man? They must have been conscious of it, but perhaps not yet come to articulate so overwhelming a truth. It is doubting Thomas who is the first to acclaim, in unforgettable words, the divine Lordship of Jesus.

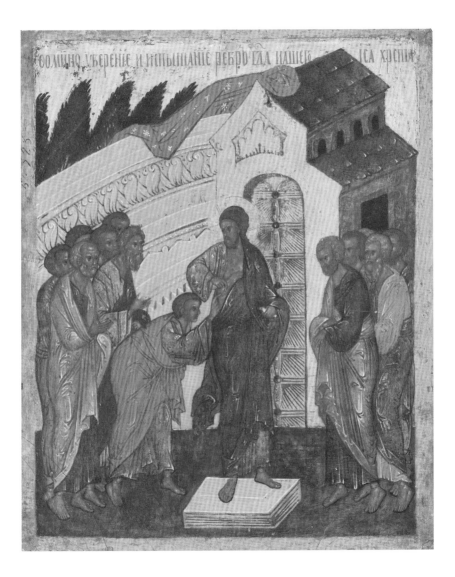

ѲОМИНО УВЕРЕНІЕ И ИСПЫТАНІЕ РЕБРЪ ГДА НАШЕГ ІСА ХРСТА

The Ascension,
1483–98, Simon
Marmion, Gheraert
Heronbout,
Alexander Bening
attrib., *The
Blessed Virgin
Mary's Book of
Hours*, Naples

Christ stayed on earth, in a visible human form, for forty days after his resurrection. St Mark tells us he impressed upon the disciples that they must go out into the world and preach the good news, and then 'the Lord Jesus was taken up into heaven and enthroned at the right hand of God'.

In this painting the apostles crane upwards, longing and yearning. St John, prominent as ever, seems utterly dismayed, while the others close their eyes in anguish and in reverence. Only Mary seems at peace. She knows that Jesus has merely gone away in a bodily sense: he is present spiritually and always will be.

From now on, people will know Jesus by faith alone; they will love him and understand his teaching, but without ever seeing him. Doubting Thomas – those may be his hands raised in a forlorn attempt to stay the departure – said he could only believe if he saw and touched the wounds. Jesus granted his request, but added: 'You believe because you have seen me. Blessed are those who have not seen and yet believe.'

Since the Ascension, we have all been among these actual or potential blessed ones. In this life we shall never see Christ, and faith that demands sight is like faith that demands proof: there can be no true 'belief' when there is evidence.

The expression on all these faces is a poignant reminder of how dear Christ was to his friends and how much he would be missed. We may feel that we can never experience this natural emotional link with him, but our fate is in fact 'more blessed': we have to choose to know him and thus discover for ourselves the happiness of his friendship.

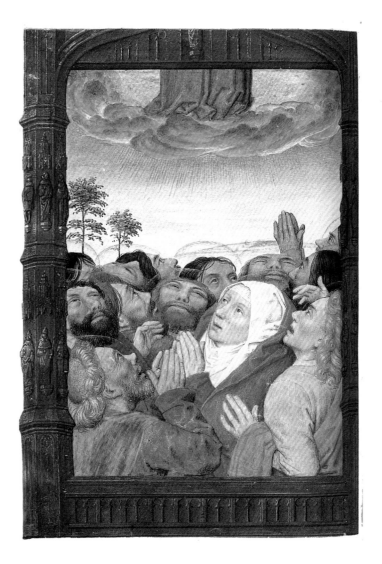